Henri Rousseau

A Jungle Expedition

Prestel

This story is about Henri Rousseau, who
was a very unconventional and mysterious man.
He lived more than a hundred years ago in Paris
where he worked in a customs office. His greatest
wish, however, was to become a painter, but not just
any painter. On the contrary, Henri wanted to be the
greatest and richest painter in France, and he hoped
that his name would one day be famous throughout
the world. In this self-portrait, which shows him on
the bank of the River Seine in Paris, he depicts
himself as a gigantic figure. His head even stretches
above the famous Eiffel Tower in the background.
The couple going for a walk along the river seem
like tiny ants in comparison to Henri, and even the
tall mast of the ship only just reaches up to Henri's
shoulder. So that everybody can see that he is a
painter, he proudly displays the tools of his trade:
a brush and a palette. When he was young, it was
not possible for Henri to go to art school to learn
the techniques and rules of painting, so he portrayed
the world just as he saw it with his own eyes.
His pictures seldom reflect reality, but
instead they reveal his

desires
and dreams.

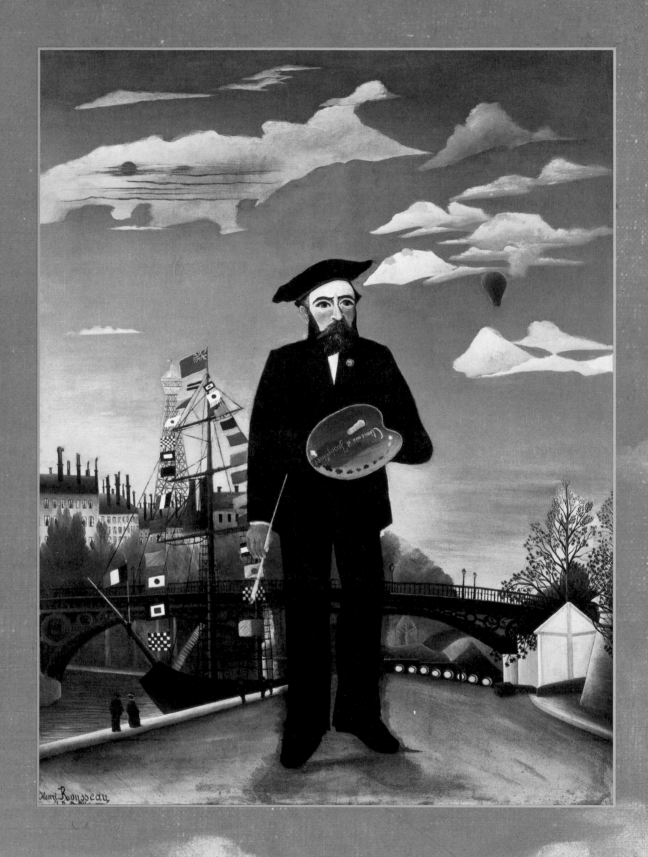

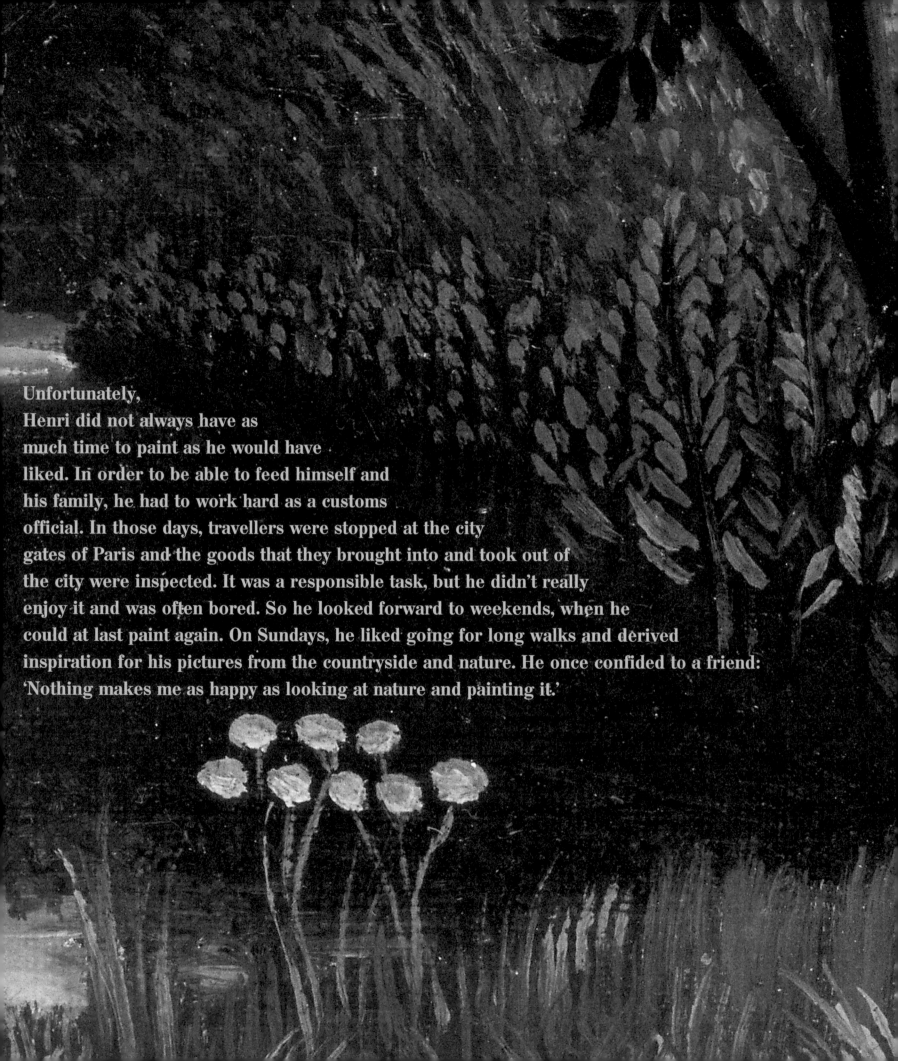

Unfortunately,
Henri did not always have as
much time to paint as he would have
liked. In order to be able to feed himself and
his family, he had to work hard as a customs
official. In those days, travellers were stopped at the city
gates of Paris and the goods that they brought into and took out of
the city were inspected. It was a responsible task, but he didn't really
enjoy it and was often bored. So he looked forward to weekends, when he
could at last paint again. On Sundays, he liked going for long walks and derived
inspiration for his pictures from the countryside and nature. He once confided to a friend:
'Nothing makes me as happy as looking at nature and painting it.'

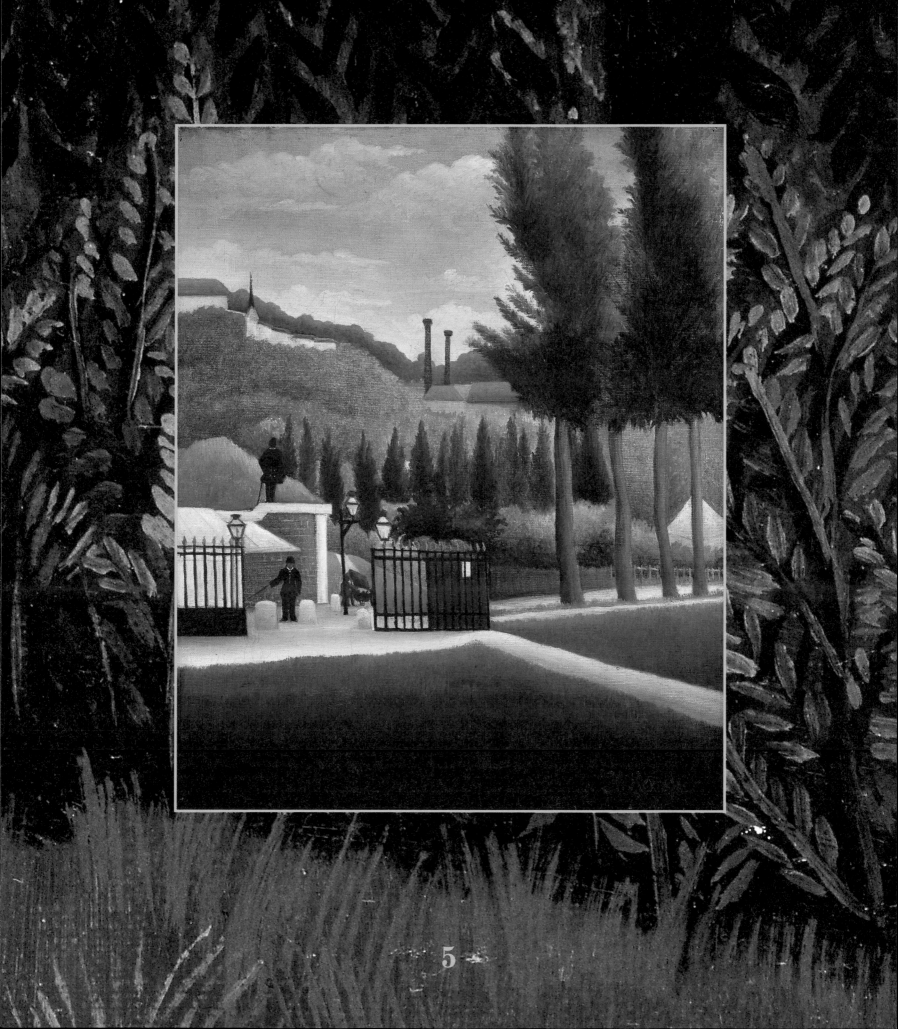

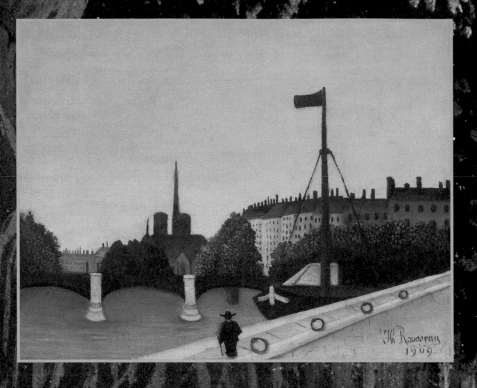

Henri set off very early in the morning so that he could make the most of the day and gather as many impressions as possible. He strolled through the spacious public parks and marvelled at the tall, mighty trees, . . .

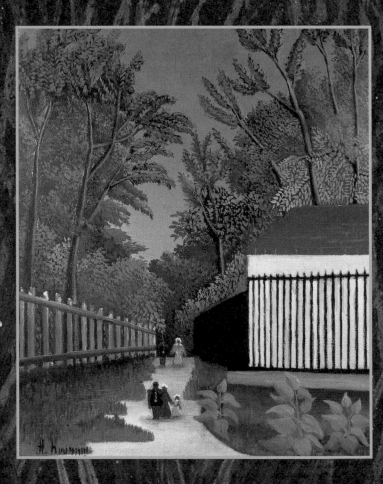

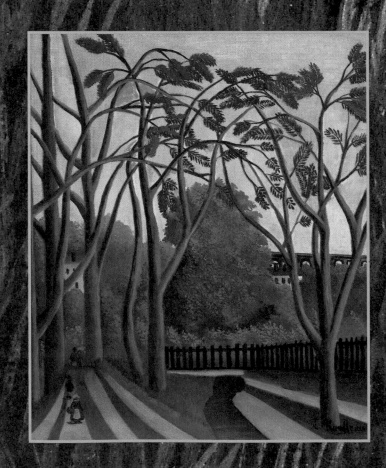

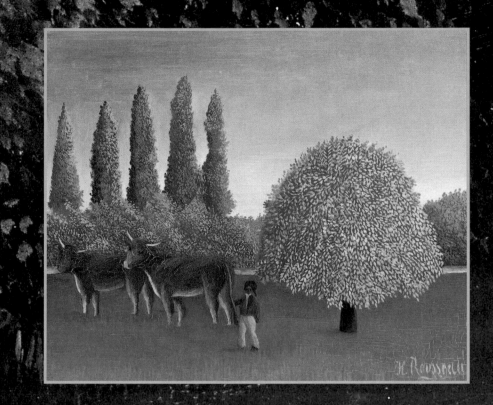

. . . he saw cattle in green fields
tended by cowherds in brightly-
coloured costumes , . . .

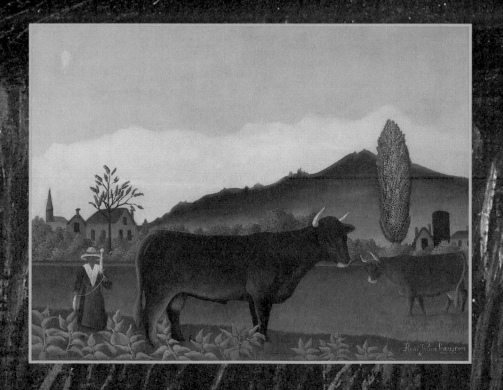

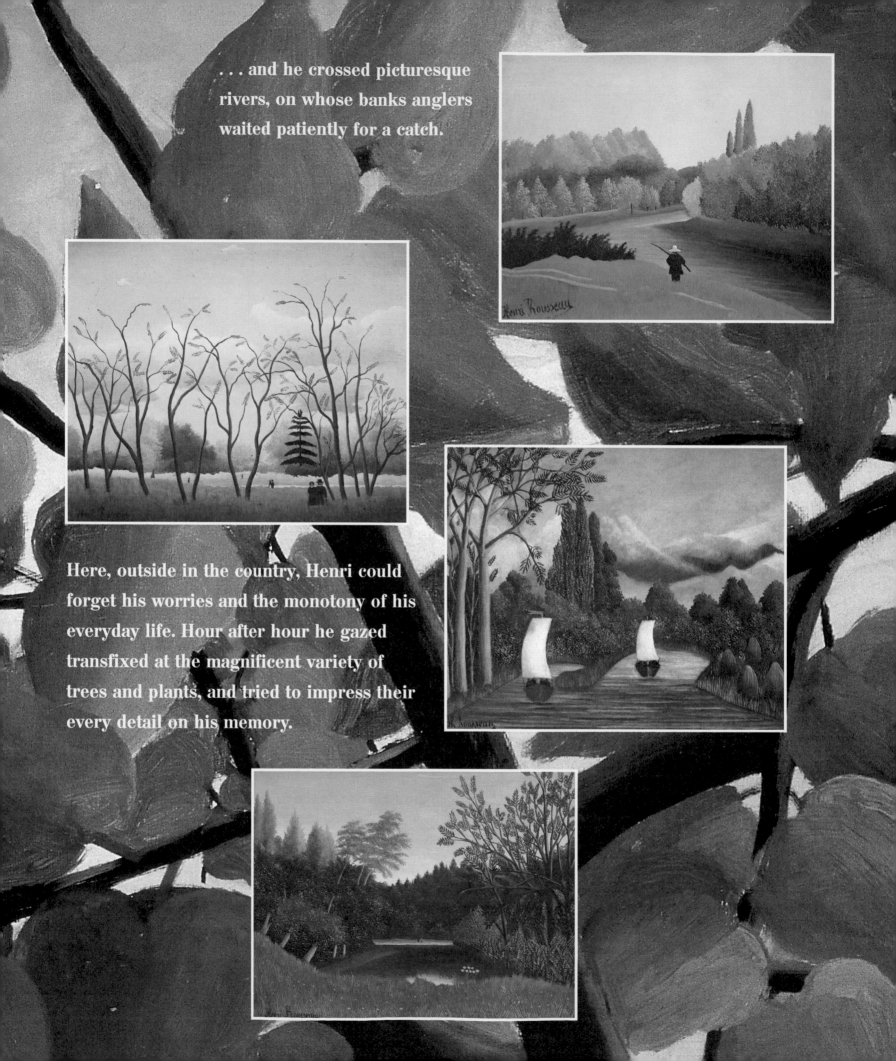

. . . and he crossed picturesque rivers, on whose banks anglers waited patiently for a catch.

Here, outside in the country, Henri could forget his worries and the monotony of his everyday life. Hour after hour he gazed transfixed at the magnificent variety of trees and plants, and tried to impress their every detail on his memory.

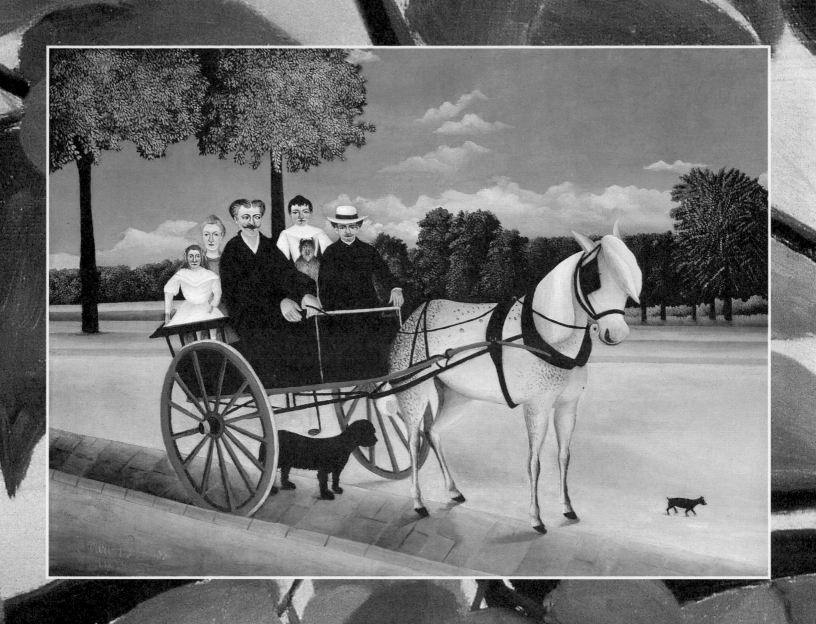

When the weather was fine, Henri met many other walkers and day-trippers in their Sunday best, and they greeted each other cheerfully.

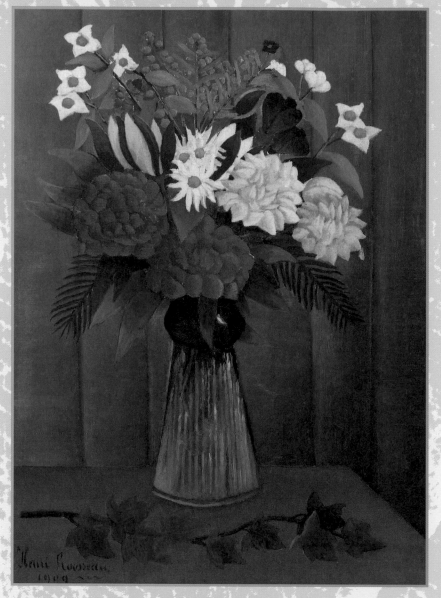

He made bouquets from his favourite sprigs and flowers, which he liked to take home with him. There, he carefully studied the different shades of colour and shapes of leaf. Henri painted many beautiful pictures of these bouquets. Then, on Monday, the drab, everyday routine would begin again at the customs office and Henri — still full of the beautiful things he had experienced on Sunday — couldn't stop raving about them to his colleagues. He described every little leaf, every flower in all its detail and enthusiastically depicted the glorious play of the sunlight in the green foliage of the trees.

10

The other customs officials liked listening to Henri, but they couldn't really understand his passion. They liked being out in the countryside too, but for them a leaf was just a leaf. Never in their dreams would it have occurred to them to do what Henri did and collect every possible kind of leaf in order to draw them.

Once — it was on a Monday and boring as usual — one of the officers brought Henri a special present for his leaf collection. At the weekend he had been on an outing with his family to the hothouse in the botanical gardens in Paris, where the most wonderful plants from far-off lands grew. To please Henri he had secretly pinched a leaf from one of the luxuriant trees.

Henri thanked him and became very excited. He had never seen such a large, thick leaf before. During the day he could barely concentrate on his work, because he wanted to keep looking at the strange leaf and draw it. He decided to pay a quick visit to this hothouse immediately after work so that he could have a look at the other plants there.

It was late by the time Henri arrived at the botanical gardens
and the attendant didn't want to let him in. But he pestered and begged
for so long that the man finally took pity: 'But just for half an
hour', he called after Henri, who had already raced off towards
the hothouse. Inside, he was met by a magnificent display
of lush green flora, the like of which he had never
imagined even in his wildest dreams. He was quite
confused by all the different kinds of plants and didn't
know where to look first. The air around him was
pleasantly warm and moist and the blossoms
gave off a strong, sweet perfume, which made
his senses reel. Exhausted by so many new
impressions, he sat down on the ground
between the plants to have a little
rest. And there he fell fast asleep.

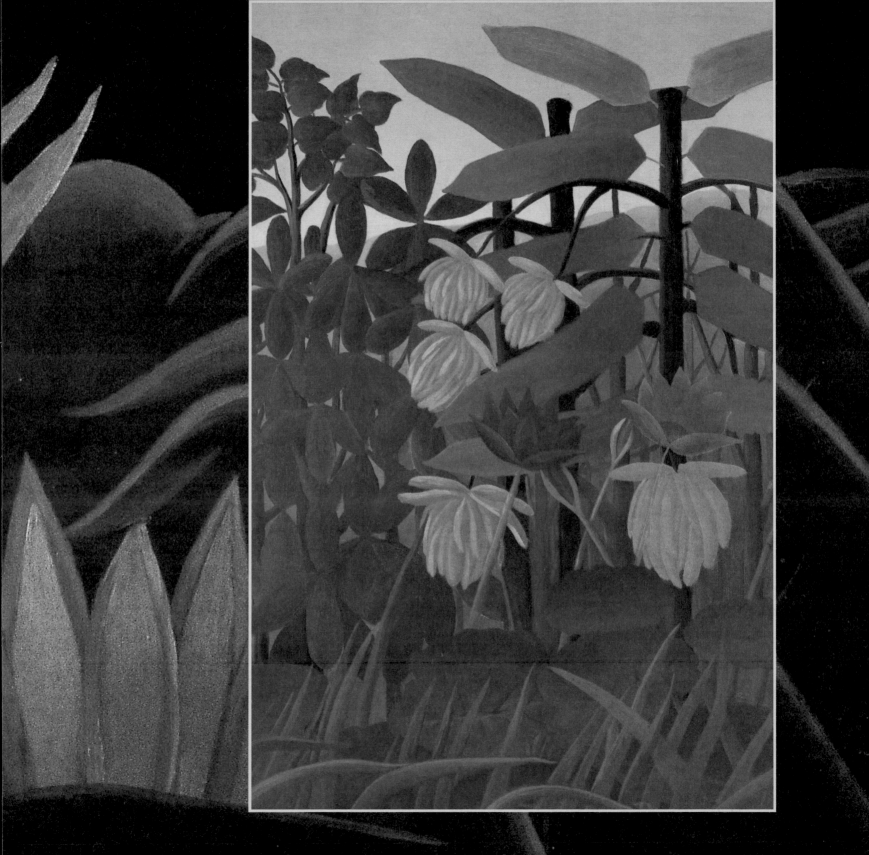

Suddenly,

a mysterious, dark figure appeared. She was playing an

entrancing melody on her flute, with which she enticed all the animals to

gather round her. Poisonous snakes became quite tame and wound

themselves around her shoulders, and a brightly-coloured bird

came waddling out of the water. Henri loved

music, he played the violin

and sometimes even composed little

pieces of music himself. But he had never heard a

melody like this before. It cast an inexplicable spell over him,

from which he could not break free. Like the animals, he

followed the sounds of the flute into the dense jungle.

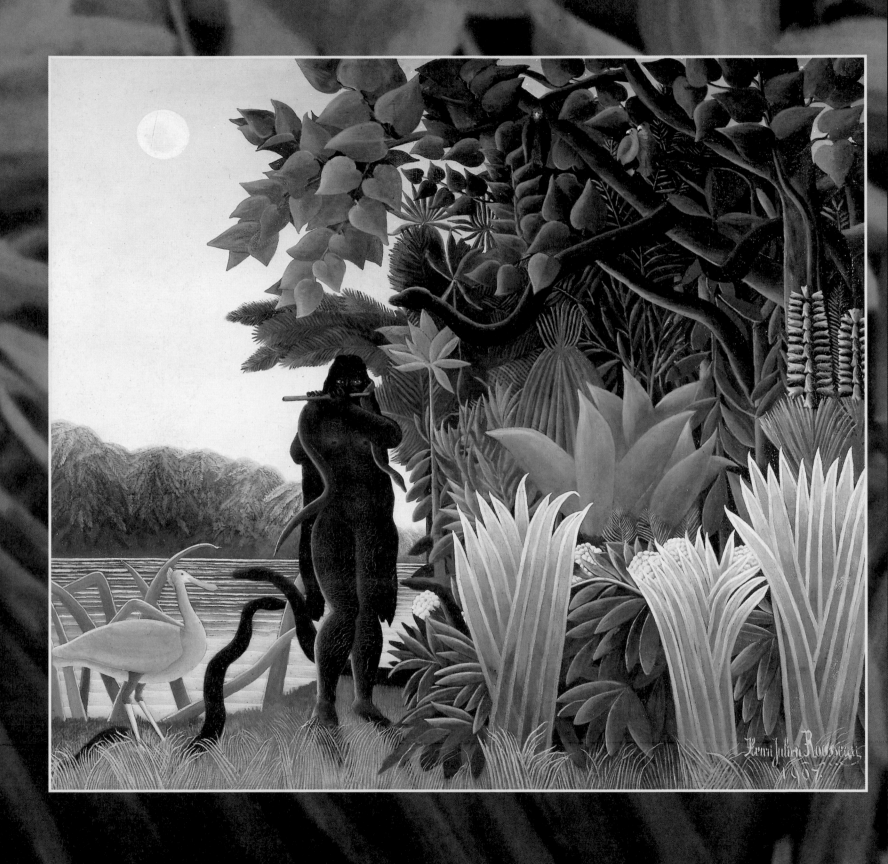

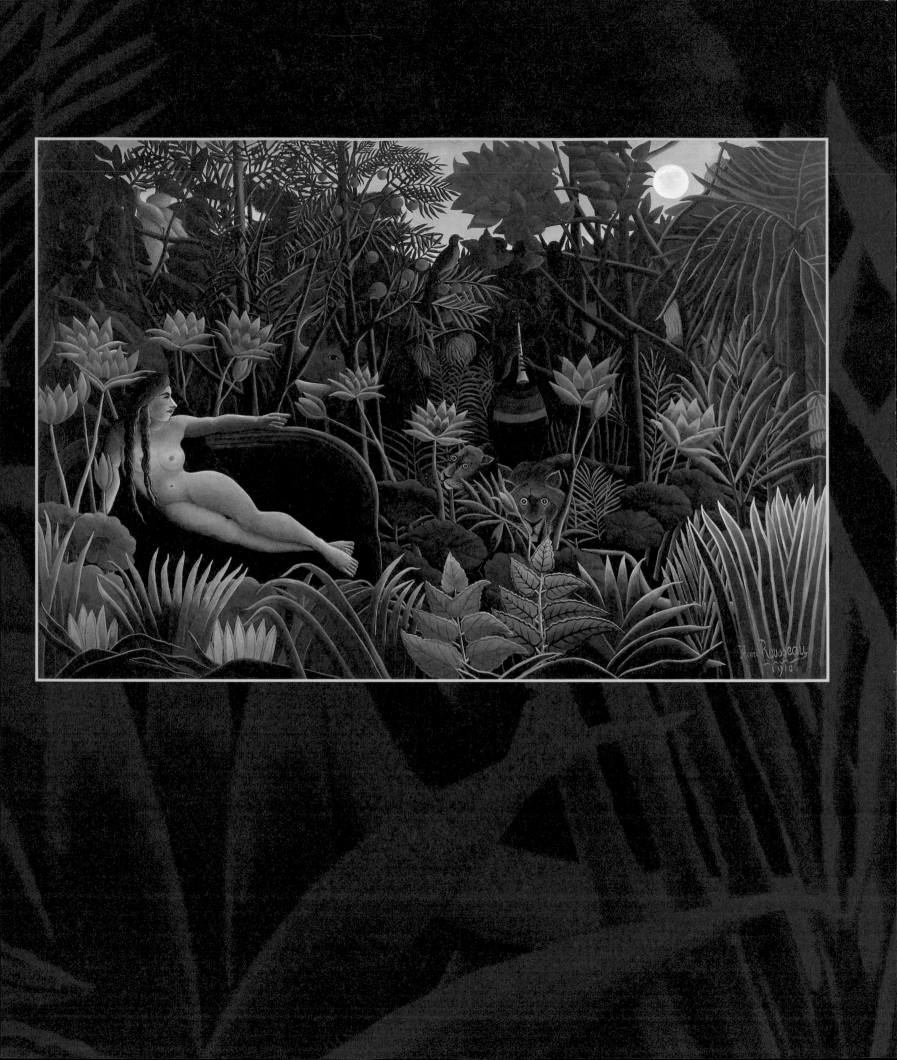

Soon Henri had lost sight
of the snake charmer, who had
already disappeared into the dense
foliage growing luxuriantly on all sides.
Even the sound of the flute became quieter
and quieter, until it faded away altogether.

Henri began to feel a little frightened, but his
curiosity drove him further into the mysterious
tropical forest. Without knowing where he was
going, he strode bravely through the thicket
of exotic flora and all of a sudden he found
that he was hopelessly lost.

Desperately he pushed aside the masses of
thick, heavy leaves and, to his surprise, saw
a beautiful woman in the midst of all the
wonderful profusion of blossoms. All the
wild animals had gathered peacefully
around her, and suddenly the flute player
appeared as well. Without saying a word,
the woman showed Henri which way to
go with an elegant wave of her hand.

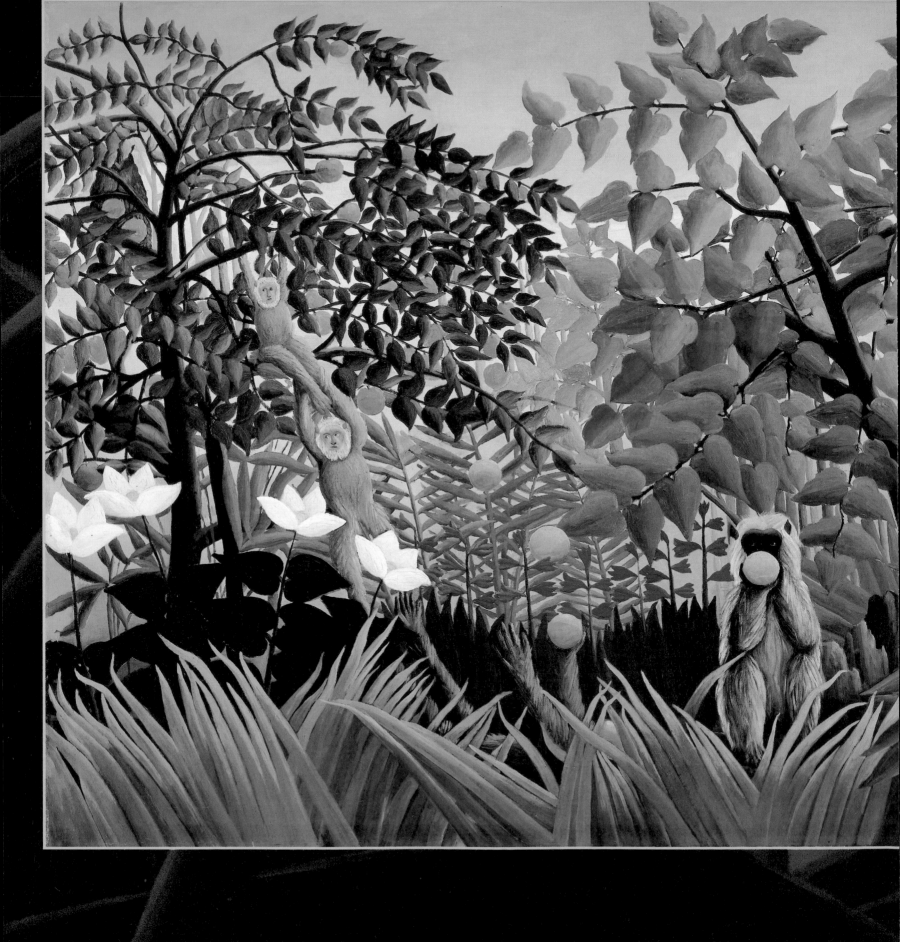

Henri turned to the right and, in the distance, could hear screeching and chattering, which — the nearer he got — grew to an ear-splitting din. A lively troop of little monkeys was romping playfully through the trees and playing with oranges. They threw one to Henri, inviting him to play ball with them. But Henri had grown quite hungry after walking for so long, so he preferred to eat the orange instead of throwing it back. The monkeys didn't take this amiss and resumed their pranks. While Henri was enjoying the sweet orange, he didn't notice that dark clouds were slowly gathering in the sky and that the cheerful chattering of the monkeys had subsided.

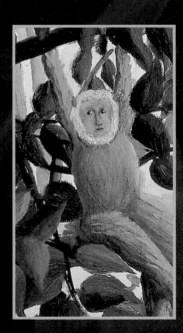

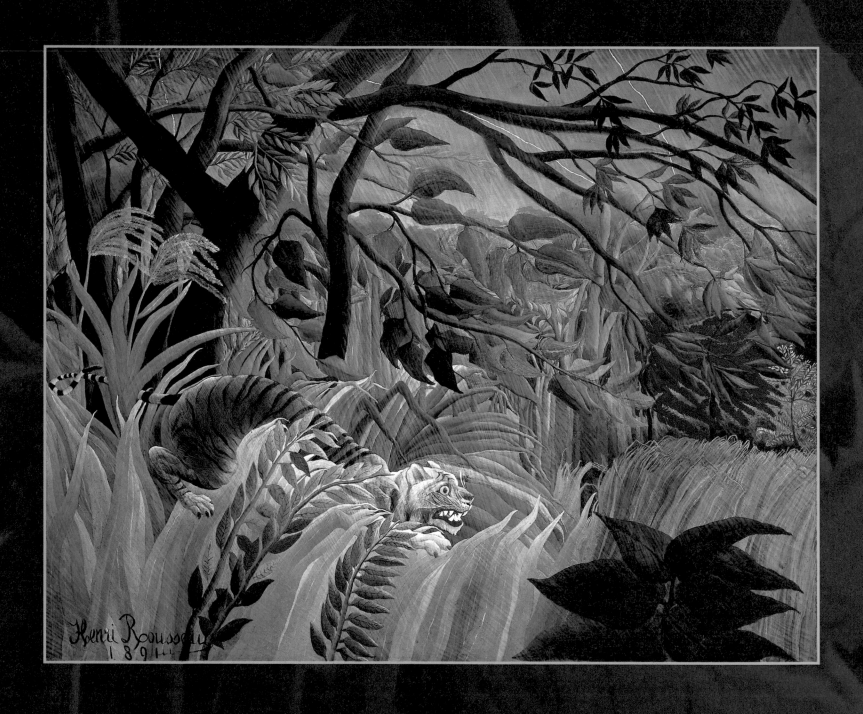

Only when a chill of suspicion ran down
his spine did Henri finally look up and
see terrible flashes of lightening in the
sky. Now it began to thunder as well and a
violent storm broke, which whipped the rain
through the tropical forest. The animals fled
in wild panic and even the courageous
tiger was afraid.

Henri sought
shelter under
a large leaf.
His whole body
trembled with
fear and cold.

21

The storm stopped as suddenly as it had started. It was a long time, however, before Henri looked out of his hiding place. The torrential rainfall had made the water in the streams and rivers rise quickly, so that there were little waterfalls splashing everywhere where the animals could drink. The sky above Henri was brilliant blue once again and the pleasantly warm rays of the sun shone on his back. Happily, he crept out from under the leaf so that he could dry his damp clothes in the sunshine and continue on his journey.

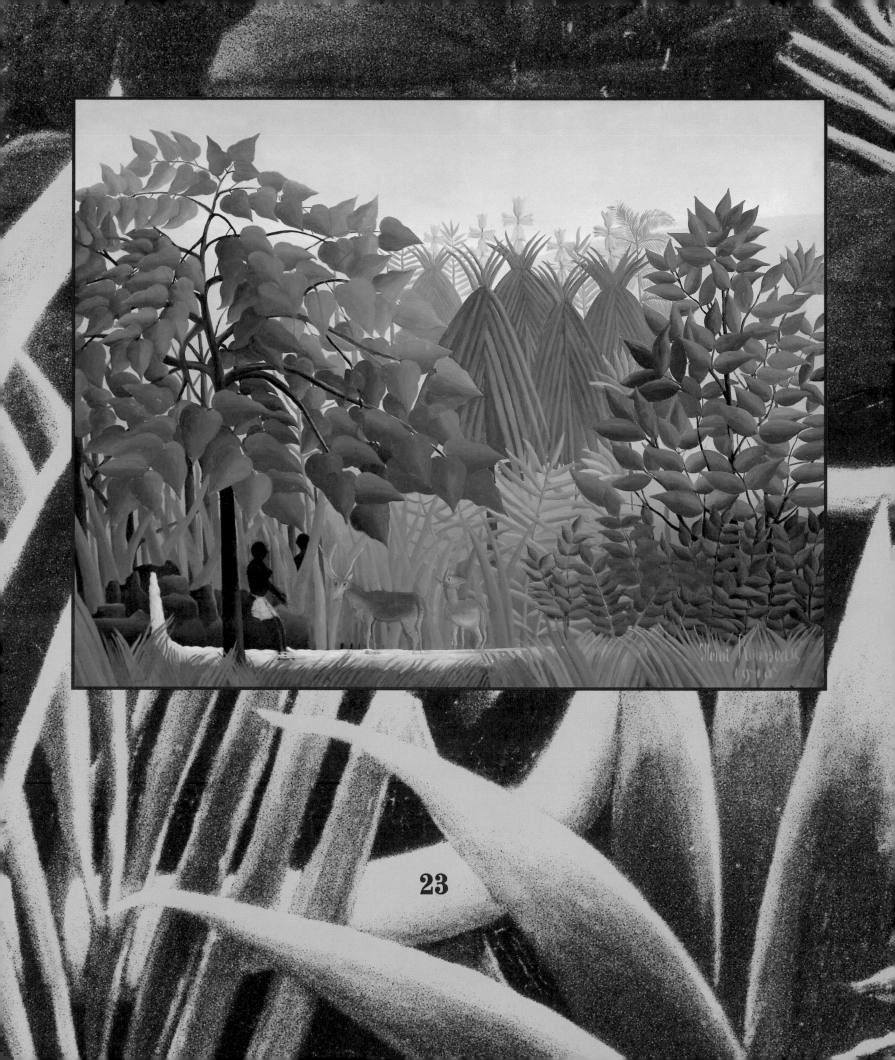

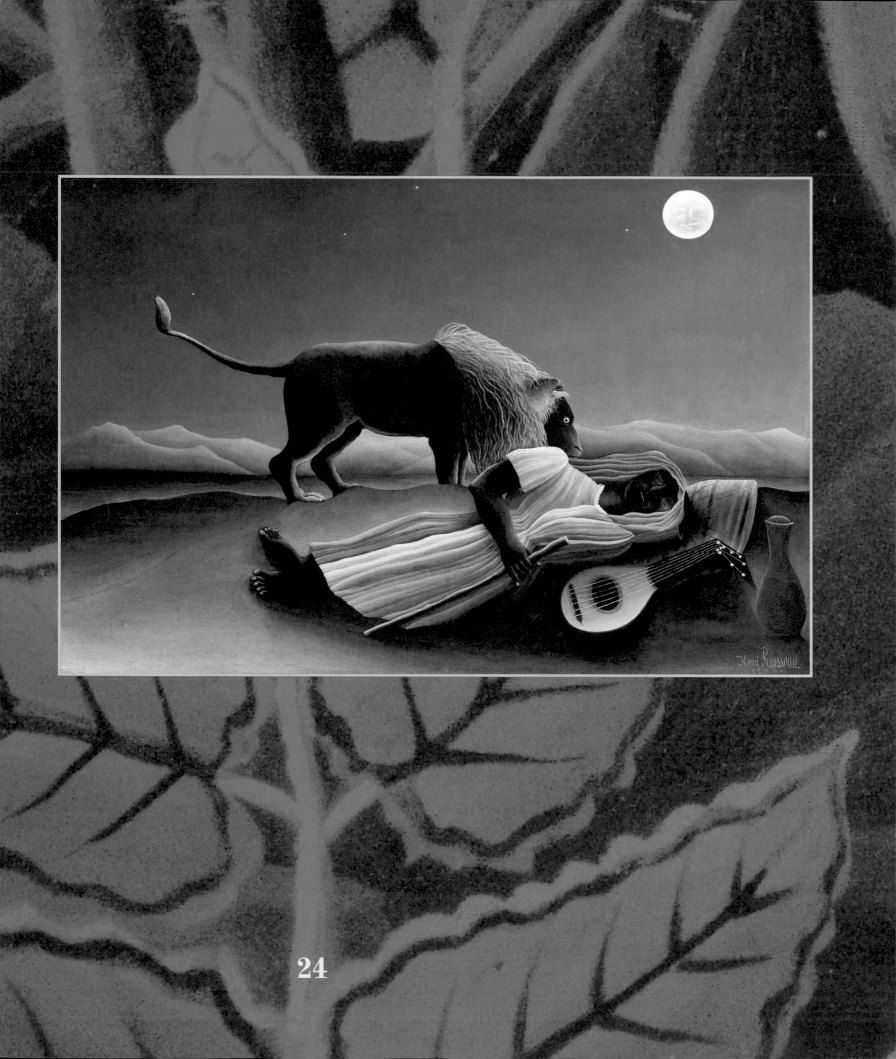

The hours passed and it began to get
dark. It was time for Henri to look for a
safe place to sleep, but he hesitated, because he
felt lonely and sad — all alone in the tropical forest.
He had not met any animals for quite a long time. Even
the birds had stopped twittering. In the meantime,
the moon had risen and was casting its silver light
on the earth. The atmosphere was sinister —
there was not a sound to be heard, not a
breath of air to be felt.

Henri
began to feel
uneasy, when he
suddenly came to a
large clearing where a
peaceful scene met his eyes.
On the ground lay a brightly-
dressed woman, whose sleep was
being watched over by a tame lion.
Henri slipped quietly up to them and
snuggled down wearily but contentedly
next to them. He slept deeply and
heavily until he felt the hard fore-paw of the lion against
his shoulder. Unwillingly, Henri opened his eyes. But to
his surprise it wasn't the lion standing in front of him but the furious
attendant of the hothouse who wanted finally to lock up and who
dragged Henri so abruptly out of his dreams.

Still rather dazed, Henri found
himself once again in the street outside the
botanical gardens. Was the exciting jungle expedition
merely a dream? No, he couldn't believe it. It all seemed
so real! But just so that he wouldn't forget this wonderful
dream, he wanted to get home as quickly as possible in
order to capture his impressions with his brush and
paint on canvas.

The Parisian moon smiled down on the happy customs
official, because it knew that these pictures would one day
make Henri Rousseau very famous
— just as he had always wished.

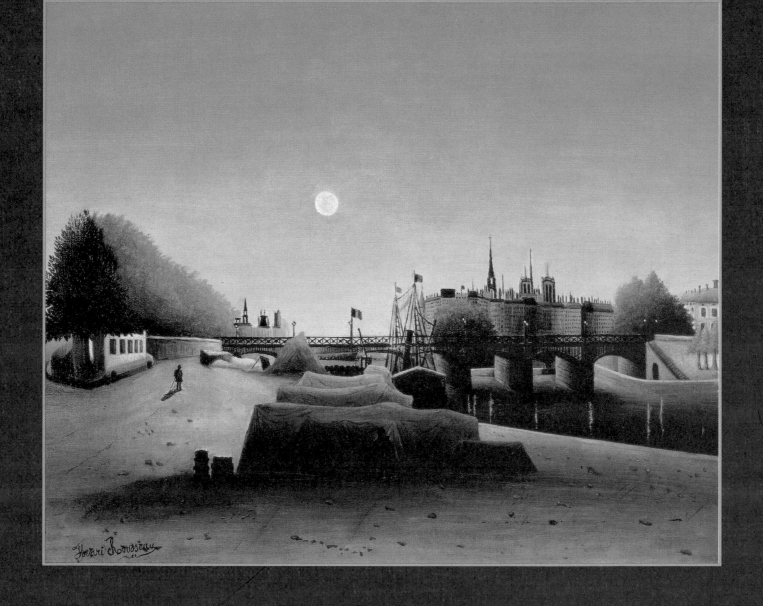

Henri Rousseau was born on
21st May 1844 in Laval, France.
He died on 2nd September
1910 in Paris.

Written by Susanne Pfleg
For Julia and Nadja

Translated from the German l
Copyedited by Michele Schon

The title and concept of the 'A
titles and design of the indiv
copyright and may not be cop

© Prestel-Verlag, Munich • Ne

Prestel books are available w
nearest bookseller or write to
for information concerning yo

Prestel-Verlag
Mandlstrasse 26
80802 Munich, Germany
Tel. (+49-89) 38 17 09-0
Fax (+49-89) 38 17 09-35

Designed by WIGEL, Munich
Lithography by ReproLine, Munich
Printed by Aumüller Druck KG, Regensburg
Bound by Conzella, Munich

Printed in Germany
on acid-free paper
ISBN 3-7913-1987-6

Fax (212) 627-9866